The dog sense that changed my life

pictures and verse
by
Sandra Magsamen

gift

stewart tabori & chang

I looked at my dog and shook my head.

"What a life -
I'd like to
live that way,"
I said.

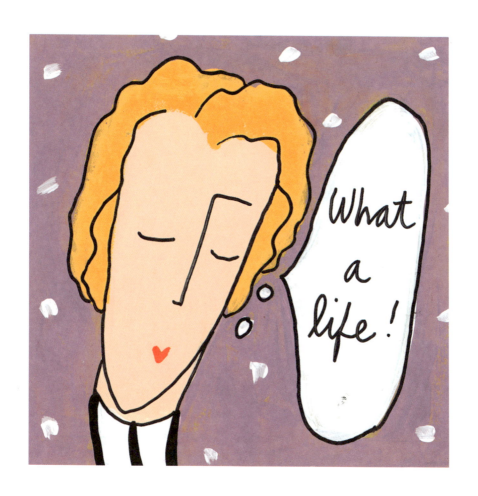

He was peacefully
stretched out
in front of
the
fireplace,

He clearly knew how to take a break, relax, and dream.

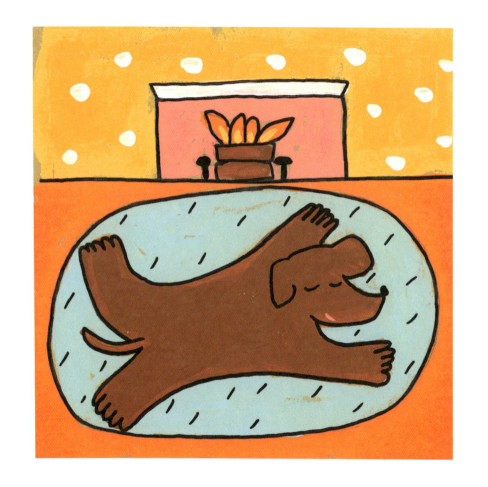

snoozing
and
dreaming
with a look of
contentment
across his face.

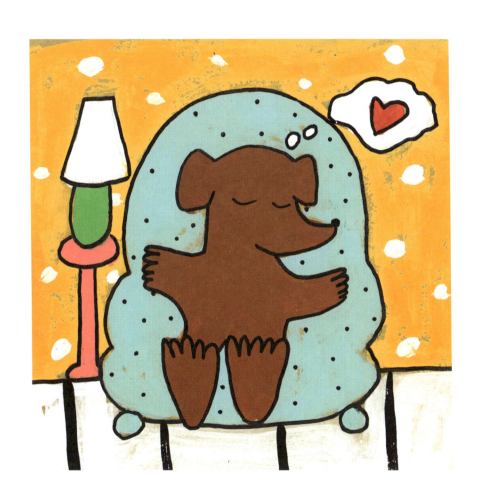

I realized there was more to my dog's knowledge than what I had previously gleaned.

I watched
him closely
from
dusk
until dawn...

He
clearly knew
how to take
a break, relax,
and dream.

snoozing
and
dreaming
with a look of
contentment
across his face.

these are the
lessons I learned,
and I am
delighted
to pass them on.

Express yourself.
Show appreciation,
concern, and
gratitude to the
people who fill
each day.

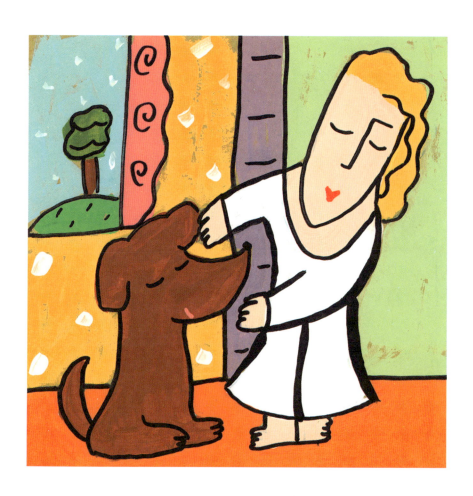

Real friendships are based on trust, loyalty, and companionship— they work best that way.

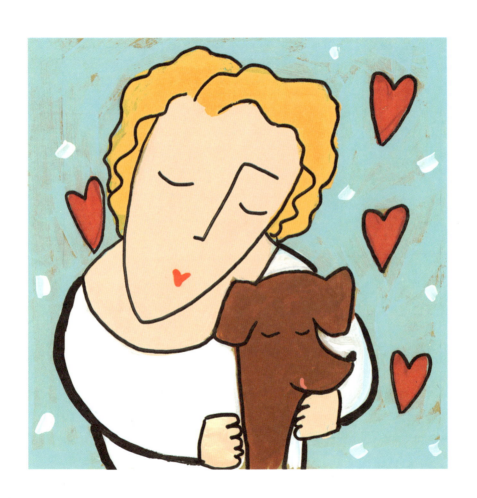

Have fun, play, and get plenty of exercise so you'll stay fit....

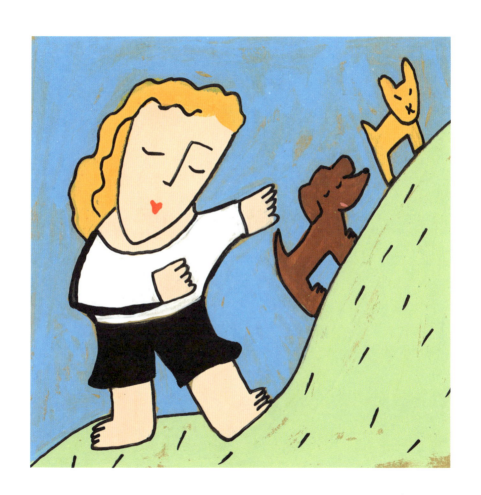

and be willing
to learn new
tricks... you'll
probably get
some treats as
you make a go
of it.

The most important thing my dog taught me is this:

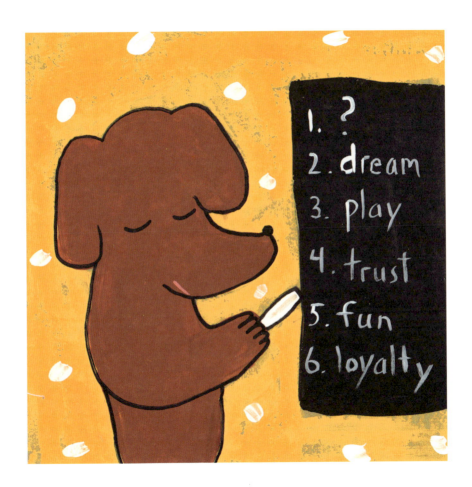

Love
with
all your
heart.

You'll always be rewarded with a great big kiss.

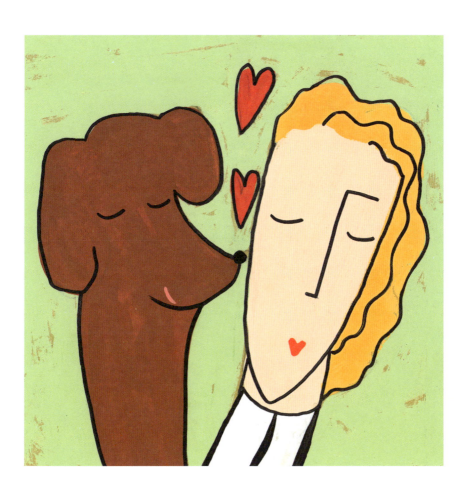

Pictures and verse by Sandra Magsamen
© 2001 Hanny Girl Productions, Inc.
Exclusively represented by Mixed Media Group, Inc. NY, NY

Published in 2001 by
Stewart, Tabori & Chang
A Company of La Martinière Groupe.
115 West 18th Street
New York, NY 10011

ISBN: 1-58479-126-8

Printed in Hong Kong

10 9 8 7 6 5 4 3 2 1